D0777079

This little book belongs to

Mom

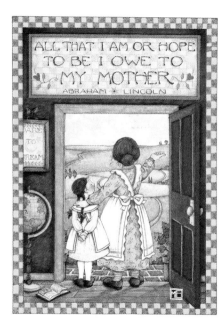

Mother O' Mine

Illustrated by
Mary Engelbreit

Andrews and McMeel
A Universal Press Syndicate Company
Kansas City

ISBN: 0-8362-4606-3

Library of Congress Catalog Card Number: 91-78253

Mother O' Mine

Where there is home,
there's a mother
who cares . . .

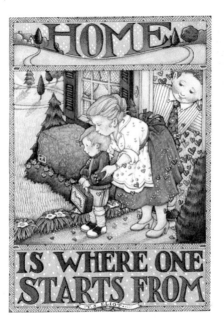

who gives comfort . . .

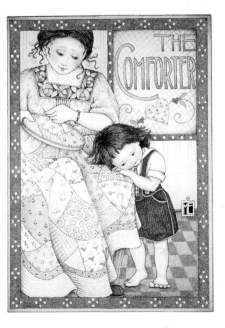

THE COMFORTER

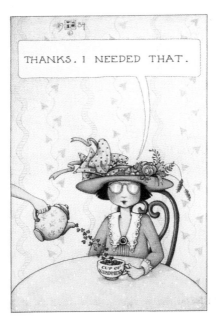

. . . who listens and shares.

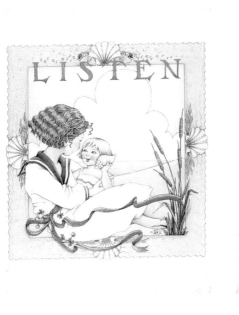

Every Mother i

Where there is home,
there's a mother
who sees . . .

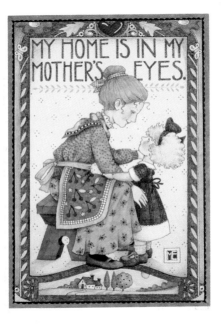

MY HOME IS IN MY MOTHER'S EYES.

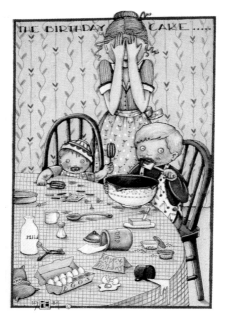

. . . and laughter,
and sometimes a squeeze.

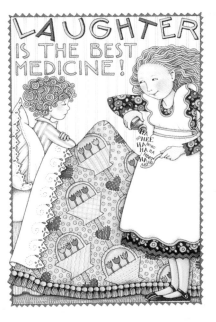

There's a mother who guides us
whenever we're lost . . .

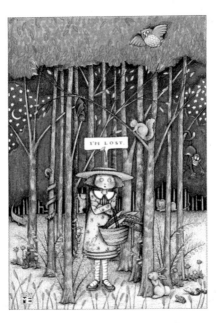

who gives of herself

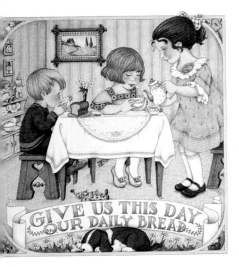

GIVE US THIS DAY OUR DAILY BREAD

without counting the cost . . .

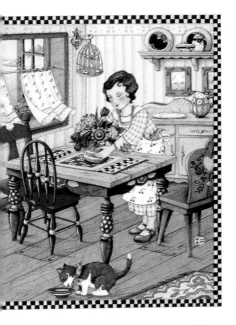

and witty . . .

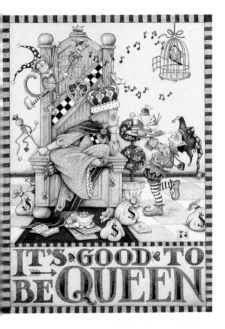

IT'S GOOD TO BE QUEEN

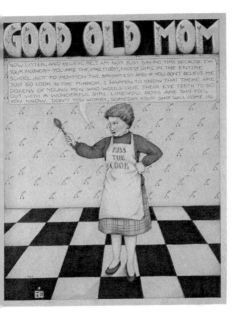

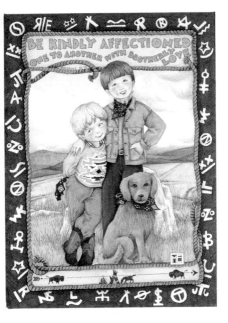

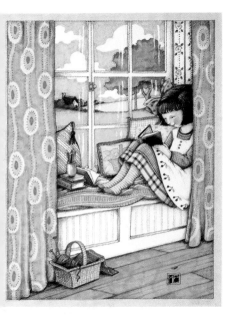

that they may need a push . . .

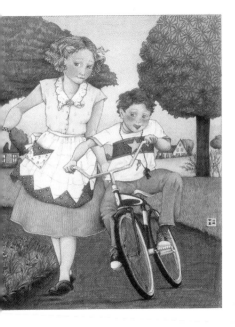

. . . if they're ever to grow.

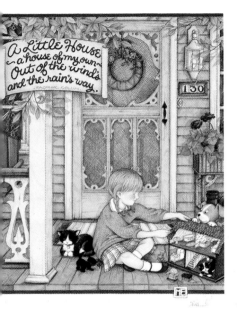

A Little House
~a house of my own~
Out of the wind's
and the rain's way.
·PADRAIC·COLUM·

130

There are children who feel
that they're never alone . . .

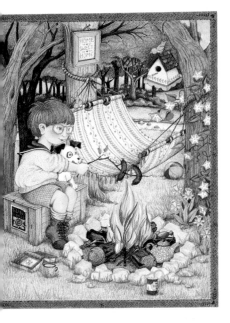

. . . for wherever
a mother's love goes,
there is home.

THERE IS ALWAYS ONE MOMENT
CHILDHOOD WHEN THE DOOR
OPENS AND LETS THE FUTURE IN.

— GRAHAM GREENE

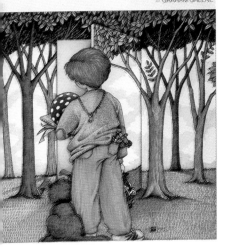

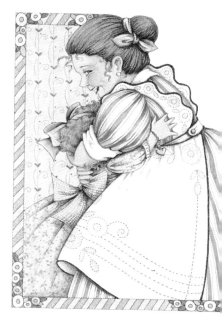